Snuff Box Theatre, for the Soho Theatre presents

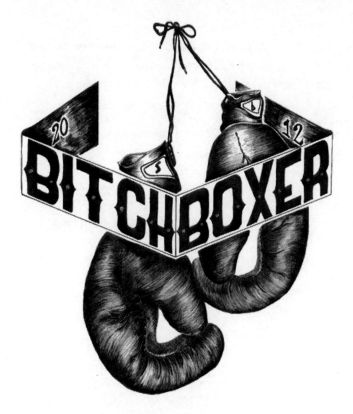

by Charlotte Josephine

(Title typeface designed by Kay Ogundimu)

BITCH BOXER

First performed as a London preview at Theatre503 in July 2012. Performed at The Underbelly as part of the Old Vic New Voices Edinburgh Season 2012, supported by IdeasTap. First performance at the Soho Theatre: Tuesday, 19 February 2013.

Character: Chloe Jackson
21-year-old female boxer from Leytonstone, East London.

The performance lasts approximately one hour.

Writer and Performer – Charlotte Josephine
Director – Bryony Shanahan
Original Music/Sound Designer – Daniel Foxsmith
Lighting Designer – Seth Rook Williams
Creative Producer – Daniel Foxsmith

SNUFF BOX THEATRE

Snuff Box Theatre is a bold collective of theatre makers who thrive on creating new work from a blank page. Founded in 2011, after training for three years together on the Contemporary Theatre Course at East 15 Acting School, the company has a rich and diverse background in performance and creative play, which drives us in the creation of our work. We collaborate with multi-skilled actors (actor-musicians, actor-writers, actor-directors and devising specialists) on each new idea, and there is always a strong sense of ensemble within the Snuff Box. Whether large-scale or intimate, political or fantastical, we have one singular aim: to tell great stories on stage.

Snuff Box Theatre is Associate Company at Redbridge Drama Centre; all details can be found on our website: www.snuffboxtheatre.co.uk

Charlotte Josephine
Trained at East 15 Acting School (Acting and Contemporary Theatre Course). Theatre includes *Perffection* (ZOO Roxy, Edinburgh Fringe Festival 2011, written by Charlotte Josephine, NSDF Commendation for writing), *Bitch Boxer* (Theatre503, The Underbelly and Soho Theatre 2012/13, Old Vic New Voices Edinburgh Season 2012, Soho Theatre Young Writers Award), *Julius Caesar* (Donmar Warehouse 2012/13).

Bryony Shanahan

Trained at East 15 Acting School (Acting and Contemporary Theatre Course). Directing includes *Bitch Boxer* (Snuff Box Theatre, The Underbelly/Soho Theatre/UK National Tour), *The Altitude Brothers* (Snuff Box Theatre, Redbridge Drama Centre), *Chapel Street* (Scrawl Theatre, UK National Tour), *You and Me* (Little Soldier Productions, Greenwich Theatre/The Blue Elephant), *Babies* (Ben Coren, Southwark Playhouse) and *Perffection* (Clay Elephant Theatre, Edinburgh Fringe Festival 2011). Assistant director credits include *Bound* (Bear Trap Theatre, Southwark Playhouse/UK National Tour) and *The Gruffalo's Child* (Tall Stories, UK National Tour).

Daniel Foxsmith

Trained at East 15 Acting School (Acting and Contemporary Theatre Course). To date, Daniel has performed across two continents and won several awards, including Best Performer at the 2011 Adelaide Fringe. He has toured the UK extensively with award-winning show *Bound* (Bear Trap Theatre Company) and more recently, with *The Gruffalo* (Tall Stories) and *The Altitude Brothers* (Snuff Box Theatre).
Writing includes *The Observatory* (The Underbelly, Edinburgh Fringe Festival 2011), winner of the NSDF/Methuen Edinburgh Fund award and the CDS/Scottish Daily Mail Edinburgh Award, and *The Altitude Brothers* (Redbridge Drama Centre, 2012), winner of the IdeasTap Innovator's Award.

Follow us online www.facebook.com/SB.Theatre
or @SnuffBoxTheatre on twitter.

Snuff Box Theatre is very grateful to the following for their support over the years: Uri Roodner, East 15 Acting School, IdeasTap, NSDF, Old Vic New Voices, The Pleasance Theatre Islington, Scottish Daily Mail, Soho Theatre, Adrian @StreetCoffee, Islington Boxing Club, GoLocalise and Redbridge Drama Centre.

ABOUT *BITCH BOXER*

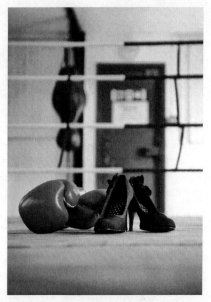

Image used for *Bitch Boxer* poster, Old Vic New Voices Edinburgh Season 2012, photo taken by Alex Brenner at Islington Boxing Club

Reviews for *Bitch Boxer*:

'Sweat-slick and tough, yet sweet
and gifted with terrific timing.'
★★★★ *Times*

'A young company to watch.'
★★★★ *Telegraph*

'A pumped-up, underdog monologue with a big heart,
delivered in a hail of upper-cuts and a spray of sweat.'
★★★ *Independent*

NOTE FROM THE WRITER:

Story of Bitch Boxer

I worked part-time in a coffee shop whilst waiting for acting jobs to appear. Lugging boxes into an office one day a passer-by made a comment about how I didn't look very ladylike. The kind of thing you can usually brush off but for some reason on that day the comment stung. I wrote a rant on my phone on the bus home, a moan at the world for insisting that women behave a certain way. Reading it a few days later, seeing a character who was really fighting for something, I shaped it into a monologue. A few days later I read that women would be competing in the boxing event at the Olympics for the very first time. The play sort of wrote itself.

Bitch Boxer was developed in the Soho Theatre Young Writers Labs. The very first draft was chosen to be performed as a scratch, by Chizzy Akudolu, at the Soho Theatre in December 2011.

Islington Boxing Club, photo taken by Reggie Hagland

I started training at Islington Boxing Club for research in January 2012. I fell in love with boxing, thick and fast, became totally addicted to training and was invited by IBC to train with the ABA competitive boxers three times a week, where I took my first big hit.

'You can't beat this guy'
Photo taken by Reggie Hagland at Islington Boxing Club

I applied, auditioned and won a place on the Old Vic New Voices Edinburgh Season in collaboration with The Underbelly in Edinburgh and supported by IdeasTap. Islington Boxing Club put me in touch with Steve 'Big Daddy' Bunce who was kind enough to invite me on his BBC Boxing Hour radio show (http://www.youtube. com/watch?v=LcR7sNeNKXc&sns=fb) and the name 'The Writer and The Fighter' was born. Boxing clubs and boxing fans up and down the country heard me on the show and sent me messages of support, links to websites, DVDs and books on boxing. I was also invited onto the Roundhouse Round One radio show (www.roundhouse. org.uk/round1). Writing during the day and training in the evenings, I was lucky enough to have the support of

Sarah Dickenson at the Soho Theatre who was invaluable in mentoring me during the script development. *Bitch Boxer* then won the Soho Theatre Young Writers Award 2012 (http://www.sohotheatre.com/whats-on/soho-young-writers-award/).

Snuff Box started rehearsing *Bitch Boxer* in June 2012 with Bryony Shanahan directing the play. In true Snuff Box collaborative form, founder Daniel Foxsmith regularly came in and helped shape the show, all working together to devise original moments within the piece. He also wrote and designed the original music/sound – all this whilst on tour, scaring kids up and down the country in *The Gruffalo*. Seth Rook Williams was our brilliant lighting designer and Kay Ogundimu designed some beautiful artwork.

Rehearsal shot at East 15, taken by Daniel Foxsmith

Dan and Seth, hard at work

We were designated a Movement-Mentor by the OVNV scheme and enjoyed exploring ideas with the lovely Imogen Knight.

Rehearsal shot, taken at East 15 Acting School

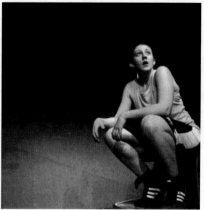

Production Shot, Theatre503, by Alex Brenner

We performed two London previews at Theatre503 in late July, both of which sold out, helping us to raise some much-needed cash.

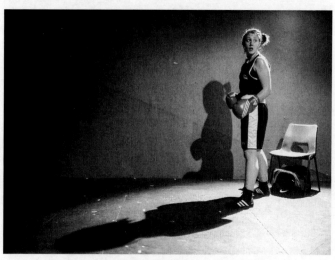

Production shot, Theatre503, by Alex Brenner

People kindly supported us on Sponsume and my coffee-shop boss (Adrian at Street Coffee) and my mum's choir (Chiltern Ladies Choir) donated some essential money. Go Localise were kind enough to shoot a promo-video (http://www.golocalise.com/blog/?p=881).

We had a brilliant run at the Edinburgh Fringe Festival, performing sold-out shows. The support from people has been amazing.

Steve Marmion offered us a slot at The Soho Theatre for February 2013. We teamed up with Scrawl Theatre Company to take *Bitch Boxer* and *Chapel Street* (written by Luke Barnes) on a double-bill National Tour, after the run at Soho. This is being mentored by the lovely Richard Jordan Productions, who is offering a huge amount of support and advice. A year later I'm still training at IBC; now a carded boxer, doc says I'm fit to fight.

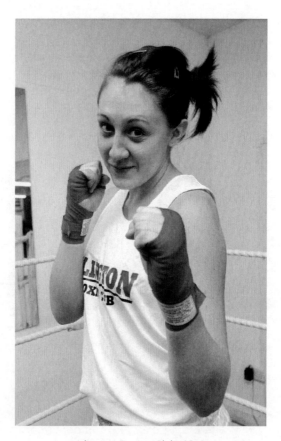

Islington Boxing Club, 2012

Note about the script

This is the original script and differs slightly from the one used in the Snuff Box Theatre production of the play. It's set in Leytonstone, East London, and is therefore written in that accent, hence the missing 'ts' and 'ings' in words I felt essential to be spelt like that. I've learnt that there are rhythms in boxing, physical patterns essential to keeping good form in the sport and that also create a percussive soundscape. I therefore wanted the delivery of the text to have a rhythm to it. Something that also nods at the spoken-word-world and pays homage to the hip-hop I listened to whilst writing and training. The punctuation therefore is deliberate as a guide to finding the rhythm of Chloe's accent and attitude. The dashes (/) symbolize a pause that is shorter than a comma.

I'd like to say a huge thank you to everyone for your help and support. First and foremost to Daniel and Bryony, my fellow Snuff Boxers. To Seth and Kay for making us look pretty. To East 15 for giving us a place to play. To IdeasTap, Old Vic New Voices and The Underbelly for Edinburgh. Thank you to the boxers and trainers at Islington Boxing Club and to the female boxers who gave me their time before competing at the Olympics. To all the Soho Theatre team but particularly to Steve Marmion, Sarah Dickenson, Paula Stanic, Jules Haworth and Don McCamphill. Thank you to Curtis Brown and Oberon Books for helping me have my first ever published play to hold in my hand. Last but not least, thank you to my family and friends for putting up with me, to my fairy-god-mother, to my mum and to my dad. Ta very much

– Charlie xx

Please see www.snuffboxtheatre.co.uk for all details about us as a company and the original production. Please contact Curtis Brown Ltd should you wish to perform the play.

BITCH BOXER

Charlotte Josephine

BITCH BOXER

OBERON BOOKS
LONDON

WWW.OBERONBOOKS.COM

First published in 2013 by Oberon Books Ltd
521 Caledonian Road, London N7 9RH
Tel: +44 (0) 20 7607 3637 / Fax: +44 (0) 20 7607 3629
e-mail: info@oberonbooks.com
www.oberonbooks.com

A catalogue record for this book is available from the British
Library.

PB ISBN: 978-1-84943-477-5
E ISBN: 978-1-84943-935-0

Cover photography by Alex Brenner

Printed and bound by Marston Book Services Ltd., Didcot.

Visit www.oberonbooks.com to read more about all our books
and to buy them. You will also find features, author interviews and
news of any author events, and you can sign up for e-newsletters
so that you're always first to hear about our new releases.

Character

CHLOE JACKSON
21-year-old female boxer
from Leytonstone, East London

The lights are up as the audience enters. The set is bare; a wooden slat bench, a hanging punch bag, a bottle of water and a kit bag. The lighting is stark and artificial in its brightness. We are in the changing room of a sports hall, in the room next-door is the boxing ring, the competition has already begun and we hear the sounds of the other boxers warming up; talking, laughing, and energetic music playing.

The actor playing CHLOE walks on stage carrying a jump-rope. She has one hour until her fight; the qualifier for the Olympics 2012. She is wearing boxing boots, fight shorts, vest and a hoody. She stands centre stage and is still for a moment taking in her audience. She begins skipping and the sounds slowly fade until she is alone. She is professional and focused, skipping centre stage facing the audience. The skipping builds in speed and intensity becoming very fast and furious until it suddenly stops and she drops the rope to the floor. She stands still, breathing hard until she has caught her breath and can speak. If her hood hasn't already fallen down she pulls it back off her face.

CHLOE: I'd woken up well late. Knew it was late before I looked at my phone. Leant over to pick it up and check the time, praying it weren't gonna be too bad. Fuck. Ten, twenty-

seven. Blind panic as I jump outta bed and run round the house trying to tidy up/ make breakfast and get dressed at the same time. Multi-tasking to the max. All bleary eyed before my mornin' cuppa. Phone on charge/ toast in the toaster/ kettle on the boil. I jump out the front door to stick the rubbish in the bins. All in the black one. Recycling can fuck itself this morning. I actually thought to myself wouldn't it be funny if, when I heard the door shut. Click.

Ah no way. You gotta be fuckin' joking. I stood there gently pushing on the door, just praying it would open. But no. I'm officially locked out. Wearing nothing but a skimpy little vest top and Jamie's boxer shorts. I ain't even got trainers on. And it's half ten in the morning/ everyone's at work, and I'm in Leytonstone. Not exactly the best place to be locked out dressed like that. I've got to be at the gym in an *hour* and my dad will *kill* me if I'm late. He'll be travelling back down from the fight in Manchester with the boys, celebrating their win, all pumped up and ready to go. He thinks

I've stuck to the straight and narrow; training, tidy house, no boys. Little does he know that Jamie's been round all weekend.

(Beat.)

I quickly hatch a plan. I reckon I can climb onto the outhouse thing we got at the back of our house 'n' try my bedroom window which is always open. But/ there ain't an alleyway, so to get into the garden/ I gotta ask next door if I can hop their fence. Which is obviously fuckin' embarrassing, I'm pretty much not wearing anything and next door's a dirty old bastard.

(Pause.)

I knock next door, but there ain't no answer. I try the house on the other side, no answer. I try both houses again, no answer/ so I move to two doors down. No fucking answer. By now I'm panicking. Three doors down on both sides still no answer/ four doors down to the left/ and some woman opens the door. She finds it funny, leads me across her shit-heap of a garden and gives us a leg up. '*Good Luck!*'

'*Cheers love.*' Fence number one done. Three more to go.

The next ones is high, it makes the most sense to balance on a little boy's bike and climb up the fence onto the shed next door. This I do, no problem, my upper-body strength is in top condition. Dropping down off the shed roof I land on the concrete/ slap/ barefoot/ inches from dog shit. Fuck me, this garden is full of it. It's like a minefield. I stand there working out the best way to weave through it all when I hear that very/ distinct/ pad/ of feet. I turn slowly and I swear down I almost shit myself. It's a fucking pit-bull.

(Sings 'please don't bite me little doggy'.)

(Speaks slowly, almost holding her breath.) It rubs its hairy head on my bare leg. And sits still staring up at me, looking confused. Somehow I don't get bit. I back away. Avoiding most of the shit, never taking my eyes of the dog.

(Breath out and launch into next section.)

Up and over the fence, across the garden to the last one. This one is rotten, a real stunner, the green mossy wood snaps under me cutting my stomach and scratching my legs/ *fucksake!* But I'm here.

(Smile.)

I made it.

I try the back door but no such luck. I shimmy up the drainpipe. I shit you not/ I zoom up there in no time at all/ surprising myself with a new-found-talent. I scramble up the outhouse roof, all the sharp shingle shredding my shins. And I make it to the window. Little breather/ before I pull it open.

(Breath.)

Now/ someone once told me/ that if a burglar can get their head and shoulders through a hole they can get the rest of 'em in. Well whoever said that obviously didn't take into account the felines of this cat-burglaring world. No matter how hard I shoved, my

lovely lady lumps were not gonna let me through. Just as I'm trying to work out how much it would cost if I just smashed the fuckin' window/ I see my keys on my bedroom floor. Next to my handbag. Next to me on the roof is a whole load of metal poles/ and bits of wood 'n' shit like that from when Dad was decorating. Long story short/ I have a moment of genius. Involving some keys, a metal pole, and a handbag. Fucking result! Keys in my mouth/ I wiggle down the drainpipe, which is/ admittedly harder than going up but I still manage it. I tried all the keys in the back door about four times each. It weren't happening. Which meant only/ one thing.

(Draw of strength, launch into next bit.)

Back over the fences, past the pit-bull now growling at me and running around a bit to the woman's back door. There I am/ covered in blood/ sweat/ and dog shit/ asking if could I please/ walk through her house again. I bounce up the road on cloud nine, leaving a bloody trail behind me, jangling my keys, I am very/ proud of myself. I feel liberated/ like a

proper/ accomplished/ woman/ like a fucking super hero. I get in and check the time, I did all that in half an hour! Ladies and Gentleman, gold medal Olympian Chloe Jackson, oh yes, I am the best/ I am triumphant/ I am the mother-fucker-champion of cat burglars! The phone rings, 'Ah/ Len! Yes mate! You will never/ guess what has just happened to me, I am the best fucking cat burglar in the world! Seriously/ I just. What?' And then he tells me. Dad's dead. Just like that. Two words.

(The bell rings. Sound effects of the gym snap back. CHLOE launches into some fast and furious shadow boxing. She has now one hour until her fight. As she warms up she remembers a conversation with LEN on her return to the gym after the funeral two weeks ago. Her movements are around one side of the bag. This allows her to shift round to the other side and become LEN, who stands still leaning on the bag talking to her.)

AS LEN: Alright Chloe? How's it going?

AS CHLOE: Alright Len. Yeah I'm good.

(CHLOE drops her hands in one rotation to stretch them as she manoeuvres around the other side of the bag.)

AS LEN: Listen. Chloe? No one was expecting you back this quickly. I mean, Christ the funeral was only yesterday. You can afford to take off more time sweetheart, honestly no one thinks/

AS CHLOE: /Nah got work to do ain't I. Only couple of weeks left.

(CHLOE ducks and dives around to the other side of the bag in one swift motion. She turns to us exhausted but impassioned. The sounds of the gym cut out for the next speech and return after 'not one'.)

I fuckin' hate funerals. Nah really/ I don't get it. All that money spent on flowers. Flowers? My dad never bought no one flowers, so why now all of a sudden was he getting hundreds of 'em? Beautiful sweet-smelling lilies lined the pavement outside the church/ shining in their crisp cellophane coffins, I couldn't believe it/ he got more fuckin' flowers than Diana. Everyone turned up, all the kids from the gym, their parents, their parent's parents,

the lot. Like a day trip out. All in their Sunday best, bloody hypocrites, not one of 'em goes to church normally/ only to get married in or chuck a load of flowers at a dead bloke. As if he can appreciate 'em. If you wanna spend your money spend it down the gym/ that's what he'd 'ave wanted, that or the pub. Not on *flowers.* And everyone kept hugging me all the time, crying on me, telling me how very *very* sorry they all were and what a terrible *waste* it was. Yeah you're right/ I wanted to say, waste of money on all this shit. And I could tell they were watchin' me, all sly like, out of the corner of puffy red eyes. Waiting for me to crumble so they could be the good ones who picked up the pieces. They shed tears like they got paid for it. Everyone sobbing their fuckin' hearts out. And I couldn't squeeze out one drop for him. Not one.

(CHLOE resumes her shadow boxing but she messes up her combination and stamps on the floor in frustration before continuing. LEN sees the mistake.)

AS LEN: Listen Clo, right. I know you had your heart set on this, but shit happens, yeah.

Honestly Clo, no one is gonna think bad of
ya if you don't wanna compete, I mean it's
understandable/

AS CHLOE: *(Stops and turns to him.)* Fuck off! Of
course I'm gonna compete! I'm not letting
anything get in the way. I can't believe you'd
even *think* I would drop out.

AS LEN: Alright, alright! I'm just worried about you
Chloe, that's all.

(Beat.)

I wanted to give you this. Your dad gave it to
me when Jan passed. I'll put it in your bag.

(Beat, he does.)

Now about training/

AS CHLOE: I'm fine. Look, if you ain't gonna train
me/ I'll go somewhere else mate.

*(CHLOE finishes her round of shadow boxing. She
appears strong and empowered, confident she has made
the right decision but conscious her every move is being*

watched for signs of weakness. A bell clangs pulling CHLOE back into the present, pre-fight. She drinks some water, puts the rope away and takes off her vest top. She pulls on a hoody and stretches her legs. The boxing-club music is still playing quietly in the next room. She stands still for a moment; her eyes closed enjoying the calm, her hands inside her hoody pocket to keep them warm. A beat before she pulls an old folded piece of paper out of her hoody pocket. She appears confused for a split-second before she opens and reads it. She looks up to us before speaking.)

It's Jamie. He's always leaving notes round the house. Sticks 'em on back of the toilet door or/ in a drawer or/ on the wall. In my pockets, in my socks. He's barmy that boy.

(Beat. She gently shadow-boxes as she speaks. The boxing-club music has subtly shifted into night-club music and it slowly fades up as the shadow boxing shifts into dancing. By the line 'I ain't been out with the girls in weeks' we are fully in the club with music and lights. On the line 'and tonight I'm feeling hot', CHLOE takes off her hoody revealing a dress underneath that she can pull down to wear over her shorts.)

We met in Destiny. It's a shit club but there ain't nowhere else to go round here. Drinks are cheap and sickly sweet, sticky dance floor clings to *my feet are caning boy*! But I carry on. With months before the fight the girls have got me convinced that *one night off can't hurt*, and besides it's bezzie-mates-forever-Katie Mitchell's twenty-first! The lights are flashing, music pumpin', heavy bass pulsing straight through my knickers. I ain't been out with the girls in *weeks*! And tonight I'm feeling hot/ downing shot after shot/ we hit the dance floor. I take on a few lads, grinding up against 'em, twirling and spinning, all the time I know he's watching me. I saw him at the bar. It's like a game, and I know I'm winning. He comes over and says sumink. *'WOT?!'* He tries again frowning. *'WOT?! I CAN'T HEAR YA!'* He gives up, laughin', and I notice he's got well nice teeth.

Outside the fresh air slaps you in the face, sobering you up quick, as I realise I left my swagger on the dance floor. In the cool light of early morning, I'm suddenly feeling pretty

shy and I'm freezin' ma tits off! He gives me
his jacket to wear. And I'm standing there/ all
tongue-tied and blushes. We ain't even kissed
yet. Katie and Lauren stagger over *'Oi babes you
coming back to mine? Let's get a taxi yeah then we'll
BLURGH!'* Katie's sick splatters the pavement
just missing Jamie's bright white trainers and
I think I'm gonna die I'm so embarrassed. He
takes my hand and it felt strange.

(Beat.)

Leaving my mates like that/ it ain't on/ nah
it's proper out of order, you never ever put a
fella before a mate, ever, it's a golden rule. But
you know, some rules are made to be broken,
right? And Jamie made my stomach flip/ oh
my god, proper butterflies.

(Beat.)

He calls me Rocky. '*Hey Rocky!*' Dick'ead. He
tells me I'm beautiful. Cooks me dinner, buys
me chocolates, perfume 'n that. It's a bit cheesy
but, it's nice ain't it.

(Pause. She shakes her head smiling.)

He likes me best when I'm ill. Says I'm too weak to keep my guard up and I just let him love me. When you've been a fighter all your life it's hard to let someone else take care of you. When Dad died I just had to get on with things you know, carry on because I didn't have the time to stop and cry about it. What's a few tears gonna do anyway? No amount of crying is gonna bring him back so I didn't let 'em fall. Just held 'em back and got on with life, like Dizzy says '*Fix up, look smart!*'/ '*Get ma shit and get gone*'. Jamie thinks I'm mad for not crying. I tell him to *shut up* and remind him that a face full of snotty tears *ain't an attractive look fella.*

(Beat.)

Love's a funny thing. Sometimes it comes along when you least expect it. You get a knock in life, and it winds you for a moment/ you can't breathe, but you pick yourself back up and you get your game face on. You've got it all worked out, totally planned, do this/ do

that/ left jab/ straight right/ left hook/ then all
of a sudden. Life surprises ya. One great big
Sucker Punch of love spins out of nowhere and
you're blinded, you're seeing stars/ trust me.
That's love/ BAM, like a punch in the guts.
You feel *sick* with it…

(Beat.)

Thing is though. I'm a fighter/ yeah and now's
my time to stand up and battle on regardless.
Fighters don't get sick.

*(Bell rings. She tugs off the dress. She leaves her wraps
on. She moves the bench, tidies away her things and
puts on another top. She catches herself in the mirror
and stops for a moment looking at her reflection. She
smoothes down her hair, and prods at an old bruise
around her eye.)*

I met up with Mum/ a few days after the
funeral. For 'coffee'. All hair spray and lipstick
she struts in like some slapper, nearly twenty
minutes late, orders a tall skinny latte and gives
the waiter a wink. Straight out of training I
sit with my tea, my top's a bit grotty/ stickin'

to the back of my chair, my face is scrubbed bare and my hair's still a bit wet. Neither of us impressed with the appearance of the other we sit in silence.

(Pause.)

Eventually she begins, says we need to chat about a few things apparently, I need to make a few decisions, like/ where I wanna live.

AS CHLOE: I'm staying at Dad's!

AS MUM: Oh yeah? And how you gonna pay for the rent? By boxing? Don't be so *ridiculous* Chloe. Look at the state of you.

(Pause.)

She left us when I was eleven. Buggered off with some bloke she'd met in Tesco/ I shit you not. Romance down the aisles, love at the checkout, Tesco's full of it. Every little helps. My dad was gutted. Like, she taken his heart, chewed it up, spat it back out/ stamped on it in her cheap stilettos then pissed all over it with

her dirty-smelly-can't-keep-her-own-knickers-
on-fanny.

(Beat.)

Came home from school and my dad was sat
on the sofa/ *crying.*

(Beat.)

He stayed like that for two weeks/ that's how
much he loved her. I smashed the house up.
School got wind of it and put me through
counselling. Some posh twat in tweed I'd never
met asking me questions 'bout my home-life?
Yeah alright sunbeam, I'd *love* to tell you all my
problems, you're from Cambridge? Oxford?
Windsor? I'm from Leytonstone. Sitting there
talking?! Nah mate, get off your arse and do
sumink about it!

(Beat.)

Dad knew what to do. Dried his eyes and took
us down the gym. Stopped me smashing things
up round the house and started me training.
Taught me to control my anger. Focus it in to

power, strength and speed. Just me and my dad fighting the world together/ and I loved it. And low and behold, natural talent. And do'y'know, after all that madness. That hot/ sweaty/ angry/ pumping/ fighting/ madness, when that all dies down and your body's sore. You feel calm. Quiet. And for an eleven-year-old who wants to smash everyone's fucking face in for what Mummy did to Daddy? That calm's a nice feeling.

(Pause.)

Every fighter's got a reason they fight. Deep down. And of course boxing's dangerous, yeah, it's really fucking dangerous. That's why we do it. It's addictive, like war is for the silly buggers who go out and fight in Iraq or whatever. It's the same thing. Addiction to that buzzy feeling you get, when that adrenaline kicks in, ain't nothing like it. And I'm good. Really good. Just one more fight to win and I'm there, The Olympics. And if I get there no one's stopping me getting gold but myself. I have this dream, where I've got lights in my eyes and sweat on my face and I can hear

the announcer's voice, *and the winner is/ Chloe Jaaaaaackson!*

(She makes the noise of the crowd and smiles.)

People saying shit 'bout my dad and how I should probably give it a rest, take a break they say. Try again next year. Fuck that. This is 2012, this is my fucking year. First year women can fight and it's in London. Of all the places in the world to pick they choose Stratford. Could have been held anywhere and it's *down the fucking road*?! If that ain't fate then I dunno what is. Someone's trying to tell me sumink though eh? It's practically on my fucking doorstep/ throw a stone and I'm there. I've got to fight. I just have to. And bollocks to all the haters. I'll prove 'em wrong. Can't be an embarrassment to that silly slag with a gold medal can I?

(Beat.)

Look, I was in the gym 'bout eighteen years old. Sweating away working the bags, out of the corner of my eye I saw my dad. Pads on

he approaches, '*Come on then kid, show me what you got.*' Two blocks/ two straights/ two body shots. Swing to two upper cuts and a heavy hook/ '*Good.*' He says. Smiling. Len too. Both of 'em like a couple of kids, big grins on their faces like they've won the lottery. '*What's going on?*' '*You're in Clo, women are gonna fight in the Olympics 2012.*' And whooping with delight we ran round the gym laughing/ all the blokes there watching like we'd gone mad. And without saying a word, it was all agreed. That was the new goal. I'm gonna fight at the Olympics. We made battle plans like it was Waterloo. Stuck charts up on the wall, a carefully precise organisation like I'd never seen. A beautiful thing. My dad and Len, in their element. Every competition planned, every fight one step closer to my new dream. A chance to prove to the whole world I'm worth sumink, to prove 'em all wrong. Women can't box? You watch. And now it seems that's all I've got. Just that one shot. That one chance to seize everyfink I've ever wanted. Capturing that moment with my dad at my side. Full of smiles, brimmin' with pride.

(Beat.)

And now he's not around I'm gonna do it anyway. Cus I know that's what he'd have wanted.

(Beat.)

Sitting still, I listen to the sound of her manicured nails absent-mindedly tapping the side of her glass as she impatiently waits for me to speak. She's offered me a room at hers/ but we both know that ain't gonna work out. Jamie's said I could stay with him.

(Beat.)

All I wanna do is box. She just don't get it/ silly slag, only one who did was my dad. '*You gotta fight for the things you love Chloe.*' Yes Dad.

(Beat. Bell rings. CHLOE tightens her hand wraps and gloves up as she speaks.)

Sometimes Jamie kisses my chin. Then he does this/ nuzzle thing on my nose/ with his nose, like the way lions kiss. It's a nice feeling. And

it's the closest we ever get you know, those lion kisses.

(Pause.)

Jamie only met my dad once. He came to watch one of my fights, sat there ringside/ smiling, pint of lager in his hand, even though I'd told him not to. My dad went mad. Jamie was the only thing we ever argued about. I'd get bloody earache listening to him going on and on. '*You don't have time to be messing about with boys Chloe, you're losing focus, there's plenty of time for all that after the fight.*' And I knew he was right but/ I couldn't help it.

(Beat.)

See I met Jamie two months before my dad died, to the exact day. It's like I met one just as the other was about to leave. Kinda like/ bringing it back to your chin to throw the other one.

(Slowly demonstrates as she speaks.)

And sometimes I think he was sent to me you know, to like/ help soften the blow of my dad. And then I think that's just mad cus you know/ we met in a club when I was off my face on cherry sambuca/ I'm surprised he even fancied me at all/ I could hardly walk! The point is though/ he's come along at a good time. And sometimes I can't believe how lucky I am.

(Smile.)

He's proper perfect. Well/ as perfect as a bloke can be I suppose. I don't like some of his trainers, and he's got pretty awful taste in music, his feet are *minging*, and he's got weird hands.

(She laughs as she reaches for her gloves and puts one on.)

Sort of bumpy fingers/ so like when we hold hands they don't quite fit right. It's sumink I've tried to ignore but it's always secretly bothered me. My hand fit perfectly in Dad's.

(Beat.)

I'd slip my hand in Dad's whilst we walked to the shops or sumink and he'd look down at me and smile. We used to hold hands everywhere/ Dad and me, probably started as a way to stop me from running off/ little shit, but when I grew up a bit/ I still held his hand. Liked the feel of it. Got to that age though at some point where I didn't want to hold Dad's hand anymore, wasn't cool. I remember finding excuses to pull away, looking for stuff in my pockets or faking this like/ burst of energy to run ahead. I could tell that he was hurt by it, but he never said nuffink.

(Beat.)

And I kinda regret it now. I wish I'd just thought fuck you to the other kids in the playground and just held my dad's hand forever/ but you don't at that age.

(Beat. She puts the other glove on and stands up.)

Dad taught me to have pride, in myself and what I do. '*Be proud of the decisions you make Chloe.*' Yes Dad. '*But remember – mistakes are*

there to be learnt from. Now get back on the bags and sort it out.' Yes Dad.

(Round of punches in mid-air, suddenly stops.)

I wish I'd never been embarrassed/ I wish I'd been proud of holding Dad's hand/ cus yeah, I miss it now sometimes. Jamie's just don't fit quite right.

(CHLOE slowly puts on her gloves, a perfect fit.)

'You're losing focus Chloe, forget everything else and think about the fight.' Yes Dad.

(The bell rings. CHLOE works the bag, hard and fast. She stops, exhausted, her hands on her knees, breathing deeply. She finds some strength inside herself and starts again, hitting the bag, bobbing and weaving.)

'*Move faster Chloe.*' Not now Dad.

'*That's it use your jab, use your jab.*'

I am!

'Move your feet! Move your feet! Don't get tired on me yet girl. Now jab and a hook! Jab and a hook! Don't lean! Use your reach!' Not now Dad! *'Work harder Chloe, go go! Hit the bag, hit the bag, hit the bag, bam-BAM, bam-BAM, bam-BAM, hit the bag Chloe, go, go! Bam-BAM, bam-BAM, bam-BAM!'*

(With a 'fuck off!' CHLOE throws a final big punch, she is exhausted and angry. Her hands on her knees she breathes hard, then walks around breathing and stretching her arms before beginning to work the bag again. She weaves around the other side to become LEN.)

AS LEN: Time! Stop Chloe! That's enough for today. You need a rest. You're pushing yourself way too hard. Take a day off and come back tomorrow and we'll talk about next week.

AS CHLOE: What do you mean talk about it? I'm ready.

AS LEN: You're done for today. Go home. Now!

AS CHLOE: You can't tell me what to do, you're not
my dad. Fuck you, I don't need this, I'll do it
on my own!

*(CHLOE rips her gloves off in frustration and shoves
everything into her bag. She turns out to us and drops
the bag at her feet, to the right of her. She stands still
until she has caught her breath and can speak.)*

I've fucked it right up with Jamie.

(Beat.)

I got back from the gym. And Jamie's sat
on the sofa. That ain't particularly unusual I
know/ but the thing is he had this huge smile
on his face. And I'm like, *'what's going on?'*
And he's like *'nothing.'* And I'm like *'what's
going on?'* And he's like *'nothing.'* And I'm like
*'well what you sat there smiling at then, you look
like a nutter!'* And his smile gets bigger. And
he goes *'I got you sumfink'.* And it's a pair of
trainers. Jamie's bought me a pair of trainers.

(Beat.)

And I can tell you're probably sat there thinking, so fucking what? It's a pair of trainers, what's the problem? Nobody died. Except that's exactly the point. Jamie bought me the trainers cus of my dad. See, it was that book Len gave us. About grieving for people. Like, when they die. And it's a pile of wank it really is. Jamie and me was reading it together one night, and we're just pissing about laughing at it, cus it's all like '*you need to share your feelings.*' And there's this bit this woman wrote/ about when her husband died/ and she said she felt like she was just floating along through her days without really paying attention to anything/ like she'd lost her feet/ yeah, which I found really fucking funny. Lost her feet. And I'm crackin' up laughing/ *'she's off her nut!'* And Jamie goes, *'do you ever feel like that?'*

(Beat.)

No.

'If you ever do, just tell me yeah, I'll sort you out'.

Oh yeah? How you gonna do that then?

'Oh I'll think of sumink'.

(Beat.)

So I'm standing there holding these trainers
and I dunno what to do. He just looks at
me, and I realise I've kinda fucked up a nice
moment/ like this is meant to be all special and
romantic and that.

'Don't you wanna try 'em on?'

Nah I say/ in a minute. I wanna walk out but
I curl up next to him on the sofa and bury my
face in his chest. Lynx Africa fills my nose, I
usually love that smell but now I just feel sick.
He wraps his arms around me and kisses my
head. Then he makes it worse by going/

*'I love you Chloe. And I know you're sad right now cus
of your dad but you won't be for ever, I promise. I'm
gonna look after you.'*

And I go to say sumink, you know, witty 'n
clever, to lighten the mood and clear the air.
But my throat closes up. I like, choke, on my
words, and I'm trying my best to spit 'em out

but it ain't happening. And I'm freaking out,
thinking about my throat and wondering why
I'm not crying and when I zone back in Jamie's
still talking. He's asking me a load of questions,
going on and on and I ain't been listening
when I hear him go/

'*What do you think?*'

(Beat.)

Said I don't mind.

'*What's wrong darlin'?*' / Nuffink.

'*Do you wanna like/ talk/ about anyfink?*'/ Nope.

'*You do love me don't you Clo?*'

(Beat.)

I didn't say nuffink but he still went mad.
Started pacing up and down the room,
shouting at me, he got well lairy/ punched the
wall/ dick'ead. Said he/

*'didn't understand what my Fuckin' Problem Was,
I'm Trying my Best 'ere darlin', you're just a selfish
Bitch that don't care 'bout Nuffink but Boxing,
didn't even cry at your Own. Dad's. Funeral?!
You're just a Selfish Cold-Hearted Bitch/'*

(Dangerously cold.) / Well why don't you just
fuck off then?!

(Beat.)

And he has.

*(Slight pause. CHLOE picks up the bag and looks to the
door at the side of her. She turns back to us.)*

When the girls asked what happened the only
thing I can think to say/ is to tell 'em that he
bought me trainers. Yeah, we broke up cus he
bought some trainers/ and they're really nice
ones. And people just don't get it. And I don't
really know why I done it either, cus if I'm
honest, it fucking hurts. He done the nicest
thing anyone's ever done for me by buying me
them trainers. Cus of what they meant. And it
was there in front of me, he was offering me

this huge thing/ a life with him in the form of some gold 'n' white Nikes. And I'm thinking, go on Chloe, just put 'em on, go on I fucking dare ya/ you deserve it/ they're well nice! But I couldn't do it. Wouldn't have felt right. Like walking around with your shoes on the wrong feet. Dad always said footwork has to be spot on, you gotta *dance* Chloe.

(Beat. CHLOE kicks off her boxing boots and shoves them in her bag. She sits on the bench, her head in her hands. Out of the shadows appears LEN who sits next to her.)

As LEN: (Softly.) What you doing 'ere sweetheart?

AS CHLOE: Ain't got nowhere else to go Len.

AS LEN: What's happened with Jamie?

AS CHLOE: (She shrugs.) Dad always said I'd be stupid to get involved with boys. Said I'm a fighter, and I don't have time for all that.

AS LEN: (He sighs.) Listen Chloe I *loved* your dad, he was my *best mate* in the *world.* But

sometimes, he was an arsehole. You've gotta do what's right for you love.

AS CHLOE: Yeah but what if I want both?

AS LEN: Then you've cut yourself out for a lot of hard work I should imagine. Get some sleep Chloe. I'll be back at nine, we'll run through some stuff then, get you ready.

(He starts to leave.)

AS CHLOE: Len. Sorry I've been such a twat to you.

AS LEN: *(Smiles and shakes his head.)* You can make it up to me by winning tomorrow.

(LEN exits. CHLOE watches the space where he was for a while before pulling the trainers out of her bag. She holds them for a moment looking at them. A decision is made. CHLOE places the trainers on the bench and checks the laces on her boots and puts on her gloves. She appears calm and soft, almost younger as though checking her bag before school. She stands, takes a deep breath and steps forward. Lights burst on and the sounds of the boxing hall erupt around her. It is exciting

*if a little overwhelming. Testosterone and adrenaline
fill the air and infect everyone; it's electric.)*

And suddenly I'm here. Months of training,
and this is it. Len's smiling at me and I force
one back. I'm so full of nerves I feel sick
with 'em. He adjusts my gloves, tells me
to box sharp and clear, talking right in my
ear, knowing I can't hardly hear above the
crowd. Last minute advice I must have heard
at least a thousand times, but right now it's
like I'm hearing it for the first time and I'm
trying desperately to stamp it onto my brain
and remember every/ single/ word. My legs
start bouncing all on their own. Little hops
backwards and forwards. I try to shake the
tension from my shoulders so my fists can fly.
Looking across to the opposite corner I catch
her eye. Like me she's hopping from one foot
to the other, practises a jab and then another,
thumping her gloves hard together she tries
to stare me down. I ignore her, knowing it's
all front. She's just as scared as me. Her heart
is beating loud in her ears like mine. Her
stomach crunching jumpy nerves like mine.

The two of us the same. Both bringing our A-Game to this one shot we both got at the title. Suddenly I realise I could *win* this. I can't lose. Either way it's gonna be painful. The only thing I can do is stay calm and focus on her for every second. Her hands, her feet, her rhythm and beats in between her jabs, the sharp breath that she takes, the tiny movements she makes? All clues to help me through to the end. Len leaves the ring and I'm alone. Just me and her. Then all that is left, is time for one last deep breath, as we're called by the ref to touch gloves. I wish Dad was here. The bell rings.

(Bell rings. Sound of the crowd, occasionally shouting encouragement. CHLOE speaks the next section in between punches.)

First round is scrappy. Both of us feeling our way. Learning how each other fights. She lands a few stunners. But I'm quick to counter-attack. First round is probably hers.

(Crowd erupts again as CHLOE stands still in her corner with her arms outstretched on the ropes.)

Everyone's shouting and I can't hear anything
that makes sense. She's in her corner listening
to her coach. Her face, eager for some golden
words of wisdom as he demonstrates what he
wants her to do. She smiles and nods, and as
he pats the side of her head and smiles back,
placing his forehead onto hers for a moment,
it's suddenly clear, that he's her dad. I rise
from my corner early, keen to get this shit
done, and stand alone waiting for the bell.

*(The bell rings and CHLOE explodes into action. The
first half of the round is definitely hers; she boxes well
with good skill and aggression. She seems to be almost
enjoying herself, confident in the knowledge she is doing
well. Towards the end of the round she is lax in her
defence and is caught by a few shots that she should
have easily blocked. The bell rings and frustrated she
returns to her corner. Crowd erupts again as CHLOE
stands still in her corner with her arms outstretched
on the ropes.)*

Len's shouting at me. Something about
keeping my guard up and using my uppercut.
It's bullshit he says every time and I snap back
'I've got this!' Out of the corner of my eye I see

a rise from the seats, people standing up to make way for someone. It could be Jamie.

(Beat.) Before I can think it's 'TIME!'

(Bell rings. Crowd. She moves up again and boxes, speaking the next section in between jabs and ducks.)

I'm quickly learning her habits. Just like she's learning mine. The tiny pop-up she does with her shoulder before she throws a right, the shift in weight to duck and dive that leaves her open for just a second if I can only…

(CHLOE manoeuvres herself to the right, stepping inside of her opponent and hitting her with a combination of body shots and uppercuts. She wins a few points but takes a few punches in the process. Her opponent grabs hold of her and they are caught in a clinch before the ref pulls them apart. They dance for a moment both breathing heavily.)

Sucking in air through my nose to clear my head. I widen my eyes and blink hard, sweat is stinging but I keep them on her. I'm tired, but the worst thing I could do is show her that.

My heart is pounding so hard it hurts. Sweat running down my arms and legs, my back is dripping. My wrists ache and my hands feel as heavy as bricks but I won't lower them. My whole body's screaming for rest, for stillness, but something moves me forward, towards her. She'll be hurting just as much as me, and even though I know the pain from her punches could knock me out, I move towards them. She moves forward towards me. Both of us not fighting to win anymore, but fighting to stop it, desperate to end this crazy madness we call sport.

(Noise erupts from the crowd as both ladies move towards each other in a tired desperate onslaught of punches. The bell rings and CHLOE returns to her corner.)

Len's talking non-stop as he pours water over my head. He rubs my face and arms with a towel and rinses my mouth guard. *'You're gonna have to step up Chloe if you're gonna win this.'* I'm breathing hard and trying to calm down. *'Who's winning on points?'* Len glares at me hard, suddenly silent and I know the answer.

Dad always said you can never trust the judges. A knock-out is the only way to win this.

(Beat.)

I rise from the stool and step forward for the final round. She's already standing, rocking from one foot to the other pumping herself up. We wait for the bell.

(The bell rings and both ladies launch themselves forward with new-found strength and energy. CHLOE lands a few before being forced to block four shots moving backwards quickly. She tries to attack back and is hit square on the jaw. CHLOE drops to one knee.)

Hot pain sharp like a knife cracks through my jaw and echoes up through my skull. I bite down hard and blink back tears, my eyes are blurred and my legs feel so fucking heavy. It's like someone's pushing me downwards. I have to get up. The ref is counting in my face. Four! Five! Six! I push hard and force myself back up, a sudden rush of cool air leaves me dazed for a second. Shaking my legs to get the blood flowing, I nod at the ref who's holding my

gloves and looking into my eyes. Sucking in air through my nose I nod, I'm fine, *I'm fine.* I can feel her pacing up and down, pumped up and ready to go. *I'm fine.* The ref nods and I turn towards her.

(Noise of the crowd. CHLOE throws a few feeble shots, but her opponent pumped up on the confidence she has knocked CHLOE down is suddenly fierce and powerful. CHLOE is forced backwards again, she blocks her face as she is hit by a fierce barrage of punches caught on the ropes. She is in trouble.)

Fuck. I'm fucked. What do I do? Dad!

(Everyone is screaming and shouting. CHLOE still caught on the ropes, her opponent shows no sign of letting up.)

'*Keep your head down Chloe and look for an opening. Now Chloe! Move your feet. Move, move!*'

(Silence. CHLOE finds a way out; one hard jab that seems to take all of her energy and a double left hook; dancing round her opponent she is released from the corner, almost swapping places. CHLOE hits her with a

harsh combination; left jab, straight right, left uppercut, left hook and a big right. She knocks her opponent down. There is a beat before the crowd erupts. CHLOE backs to her corner watching the ref count to ten. She has won. She celebrates, lifted up by LEN, her hands in the air. The celebration ends with her standing centre stage, tears in her eyes, smiling.

As the noise of the crowd dies down her smile fades slightly. She is alone and winning is suddenly bittersweet. CHLOE sits on the bench, her arms wrapped around herself, cold from sweat and full of conflicting emotions. Long pause. She pulls herself together and takes off her boots and hand wraps, pulling on some warm trackies and a jumper. She lifts the trainers from the bench and holds them in her hand for a moment.)

Apparently he did watch. Snuck in the back. Didn't wanna distract me but/ wouldn't have missed it for the world.

(Beat. CHLOE puts on the trainers and stands in them, testing how they feel for a moment.)

It ain't gonna be easy but I'm not stranger to hard work. '*You've got to fight for the things you love Chloe*'. Yes Dad.

(Beat.)

When people ask me what my dad was like I don't really know what to say, do you know what I mean? I just wanna tell 'em to fuck off. I mean what was your dad like? Oh yeah? Good for you. My dad was just my dad you know, nothing special. I mean yeah, he was special to me/ but then I'm bound to say that, ain't I?

WWW.OBERONBOOKS.COM